Weiwei-isms

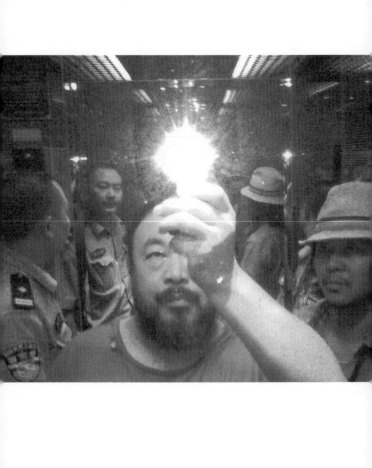

Weiwei-isms

Ai Weiwei

Edited by Larry Warsh

PRINCETON UNIVERSITY PRESS
Princeton & Oxford

Published by Princeton University Press, 41 William Street,
Princeton, New Jersey 08540
In the United Kingdom: Princeton University Press, 6 Oxford
Street, Woodstock, Oxfordshire OX20 1TW

press.princeton.edu

Library of Congress Cataloging-in-Publication Data
Ai, Weiwei.
Weiwei-isms / Ai Weiwei ; edited by Larry Warsh.
p. cm.
Includes bibliographical references.
ISBN 978-0-691-15766-5 (hardcover : alk. paper)
1. Ai, Weiwei—Quotations. I. Warsh, Larry. II. Title.
N7349.A5A35 2012
709.2—dc23 2012029359

British Library Cataloging-in-Publication Data is available

This book has been composed in Joanna MT

Printed on acid-free paper. ∞

Printed in the United States of America

1 3 5 7 9 10 8 6 4 2

CONTENTS

INTRODUCTION

Weiwei-isms distills Ai Weiwei's thinking on the topics of individual rights and freedom of expression, filtered through his responses to a range of events—the 2008 Beijing Olympics and Sichuan earthquake, for instance, or his own eighty-one-day detention by the Chinese authorities. Excerpted from Ai's own newspaper articles, Twitter posts, media interviews, and other sources, *Weiwei-isms* is organized around six themes: freedom of expression; art and activism; government, power, and making moral choices; the digital world; history and the future; and personal reflections. Within each section, quotes have been selected and ordered with an eye toward balance and flow.

For those who aren't conversant with Ai Weiwei's background, a chronology takes readers through his biographical details.

Like many throughout the world, Ai Weiwei views China's potential for greatness as measurable by its willingness to tolerate and encourage free speech among its people. In its National Human Rights Action Plan of 2012–2015, the Chinese government employs carefully chosen words to portray China as an open society, in which individual rights and free expression are fully respected. But the brutal repression of even mild forms of criticism and dissent tells an entirely different story.

China understands that to be great, it has to be good. That is, it needs to articulate a policy that respects basic human rights of free expression and personal liberty. But China wants to pursue this aim on its own schedule, so as not

to disturb the interests of power and wealth or cause the military to feel threatened and seize power from the party technocrats. It is a real tightrope.

But as Ai Weiwei repeatedly points out, and centuries of history attest, human rights and freedom of expression are not set by anyone's agenda. They are inalienable rights, central to what makes us human. For a government to deny them, in whole or in part, or to delay their implementation, is to be more machine than human. And that machine has to be challenged on many fronts. Ai Weiwei is among those leading this charge, making him one of the courageous and inspiring artists of our time.

Along with his art, Ai Weiwei brandishes the written word to expose the enormous chasm between the government's use of language and its authoritarian actions. With his own artfully

chosen expressions and idioms Ai Weiwei holds China accountable, both to its people and to the world community. For him, this struggle is a "war of words," and his own words—spoken, written, or tweeted—are "like a bullet out of the gun." Ai Weiwei's skill in wielding the brief phrase as cultural statement has gained scholarly and critical admiration as an art form unto itself.

For Ai Weiwei freedom of expression is a daily endeavor waged on Twitter, in the global media, and in his work as an artist. Ai's political stance, his life, his art, and his digital communications mesh into a continuous whole. "Everything is art," he has written. "Everything is politics."

It's no coincidence that *Weiwei-isms* is being published by Princeton University Press. Princeton University is hosting a year-long exhibi-

tion of Ai Weiwei's *Circle of Animals / Zodiac Heads* (August 1, 2012–August 1, 2013). Like the Princeton exhibition, the book will serve the effort to bring Ai Weiwei to audiences beyond the art world, particularly in colleges and universities. This effort has taken on added significance as the scope of Ai Weiwei's creative expression, and of the issues he addresses, has expanded. The Ai Weiwei Princeton exhibition and book appear at a time when human rights programs in universities have become firmly established fixtures of the academic landscape all over the world, providing a powerful network of scholarly conversation for researchers and students alike engaged in the history, politics, and aesthetics of free expression.

Watching Ai Weiwei's engagement with human rights deepen and grow over the years, we have come to develop our own strong opin-

ions about China and its future. What does a country need to truly prosper and grow? To our minds, it comes down to one essential requirement: moral goodness. The basic tenets of society and rules of decent human behavior must be met. As we see it, China will not rise as a truly great nation until it conforms to proper standards of global behavior and its people are free to express themselves without fear of reprisal.

In describing Ai Weiwei as a patriot, what we mean is this: he loves his native soil and he is willing to fight for its betterment. Every country that aspires to leadership needs an Ai Weiwei: someone who envisions the nation's greatness in ways that surpass current realities, someone who has the courage to demand more of its government and its citizens. That vision and courage are evident throughout *Weiwei-isms*.

The book's small size belies its capacity to inspire, influence, and instruct. Though the phrasing may be casual and the tone light and humorous, Ai Weiwei's "isms" cut incisively to the core of what matters in China—and the world—today.

<div style="text-align: right">LARRY WARSH AND J. RICHARD ALLEN</div>

Weiwei-isms

On Freedom of
Expression

Say what you need to say plainly, and then
take responsibility for it. (1)

———

A small act is worth a million thoughts. (2)

———

Liberty is about our rights to question
everything. (3)

———

Freedom of speech implies the world isn't
defined. It is meaningful when people are
allowed to see the world
their way. (8:16 p.m. December 22, 2011; 4)

———

The world is not changing if you don't shoulder the burden of responsibility. (4:19 p.m. December 2, 2009; 4)

———

Freedom of expression is a very essential condition for me to make any art. Also, it is an essential value for my life. I have to protect this right and also to fight for the possibility. (5)

———

My favorite word? It's "act." (6)

———

Your own acts tell the world who you are and what kind of society you think it should be. (7)

———

If you don't act, the danger becomes stronger. (8)

———

We have to give our opinion, we have to say something, or we are a part of it. As an artist I am forced to say something. (9)

———

I call on people to be "obsessed citizens," forever questioning and asking for accountability. That's the only chance we have today of a healthy and happy life. (10)

———

Stupidity can win for a moment, but it can never really succeed because the nature of humans is to seek freedom. Rulers can delay that freedom, but they cannot stop it. (11)

———

I want people to see their own power. (2)

———

Citizens should bear the responsibility to act. (12)

———

China [is a] society which forbids
any flow of the information and freedom of
speech. This is on record, so everybody should
know this. (13)

———

They all ask: Why? Why is it that this man's
name [Ai Weiwei] can never be typed on a
Chinese computer or the whole sentence
will disappear? (14)

———

A land that rejects the truth, barricades itself
against change and lacks the spirit of
freedom is hopeless. (9)

———

Without freedom of speech, there is no modern world, just a barbaric one. (9)

———

This simple form of repression, of using the method of not letting anyone speak, will never succeed. (15)

———

Writers, artists, and commentators on websites are detained or thrown into jail when they reflect on democracy, opening up, reform and reason. This is the reality of China. (16)

———

But censorship by itself doesn't work. It is, as Mao said, about the pen and the gun. (17)

———

The biggest crime of a dictatorship is to eradicate human feelings from people. (18)

———

In an environment without public platform nor protection, the individual is the most powerful and most responsible. (6:43 p.m. January 9, 2011; 19)

———

House arrest, travel restrictions, surveillance, stopping phone service, cutting the Internet connection. What we can still do is greet the crazy motherland once again. (5:58 a.m. December 9, 2010; 20)

———

At midnight they can come into your room and take you away. They can put a black hood on you, take you to a secret place and interrogate you, trying to stop what you're doing. They threaten people, your family, saying: "Your children won't find jobs." (17)

───────

The individual under this kind of life, with no rights, has absolutely no power in this land. How can they even ask you for creativity? Or imagination, or courage or passion? (21)

───────

Self-censorship is insulting to the self.
Timidity is a hopeless way forward. (22)

———

Living in a system under the Communist
ideology, an artist cannot avoid fighting for
freedom of expression. You always have to be
aware that art is not only a self-expression
but a demonstration of human rights and
dignity. To express yourself freely, a right as
personal as it is, has always been difficult,
given the political situation. (23)

———

The fundamental problem is not that
there are limits on voicing different opinions
here. The problem is that the whole society is
dying through lack of responsibility
or involvement. (22)

———

We should leave behind discrimination,
because it is narrow-minded and ignorant,
denies contact and warmth, and corrodes
mankind's belief that we can better ourselves.
The only way to avoid misunderstanding, war,
and bloodshed is to defend freedom of
expression and to communicate with sincerity,
concern, and good intentions. (24)

———

They [the government] cannot stop people from communicating freely, to get information and to express themselves. When they do that, this nation is not a right place to live. They sacrifice generations of people's opportunities. This is a crime. (12)

―――

What can they do besides exile [me] or make me disappear? They have no imagination or creativity. (5:41 p.m. November 19, 2009; 4)

―――

I cannot ever accept the kind of conditions where you can sacrifice someone's rights. (12)

―――

To express yourself needs a reason, but expressing yourself is the reason. (25)

———

My voice is not for me. Every time I make a sentence I think how many people for how many generations had a voice that no one could hear. At most they will be remembered as numbers; in many cases, even numbers don't exist. (26)

———

I also have to speak out for people around me who are afraid, who think it is not worth it or who have totally given up hope. So I want to set an example: you can do it and this is okay, to speak out. (27)

———

I tell people that because you don't bear any responsibility, you put me in danger. If we all say the same thing, then I think the government has to listen. But because no one is saying it, I become singled out, even though what I'm saying is common sense. It's very essential values that we all have to protect. But in Chinese society, people are giving up on protecting these values. (28)

———

You know, if they can do this to me they can do this to anybody, and they have been doing this for over sixty years it's a very strange world. (29)

———

If there is one who's not free, then I am not free. If there is one who suffers, then I suffer. (6:38 p.m. August 23, 2009; 4)

———

I have to respect my life, and free expression is part of my life. I can never really silence myself. (29)

———

My messages are temporary and shouldn't be our permanent condition. And like the wind it will pass. We'll have another wind coming. (28)

———

ON THE DETENTION OF
ACTIVIST LIU XIAOBO:

This does not mean a meteor has fallen. This is
the discovery of a star. (30)

ON BLIND ACTIVIST CHEN GUANGCHENG'S
ESCAPE FROM CONFINEMENT IN APRIL 2012:

The most unfair things that could have
happened in a society fell upon a blind man.
This is something that no one can accept
or explain away with any excuse. Everyone
will ask: "Do we actually have to exist in a
society like this?" (15)

ON THE 2008 OLYMPICS IN CHINA:

No matter how long our politicians order
people to sing songs of praise, no matter how
many fireworks they launch into the heavens,
and no matter how many foreign
leaders they embrace, they cannot arouse a
genuine mood of joy and
celebration among the people. (31)

———

It is as difficult [for Chinese politicians] to get
a real smile [from the people] as it is to keep
the sky blue and clouds white. (31)

———

The Olympics are an opportunity to redefine the country, but the message is always wrong. (32)

———

They tell us it will be about "emotions" and "friendship," that it will be a night of joy. Who are they kidding? (31)

———

A fine line separates Chinese intellectuals and professors from the political gangsters who protect them. (33)

———

Measuring national prestige by gold medals is like using Viagra to judge the potency of a man. (34)

———

The 2008 Olympics has created an illusion of China to the public and to the outside world. It is so fantastic, so unreal, that the entire meaning of the games is being distorted. (31)

———

Anyone who cares about truth should avoid not politics, but Olympic lies. (31)

———

It is absurd that so much money
has been wasted on manipulating public
opinion, on simulating emotion. This nation is
notorious for its ability to make or fake
anything cheaply. "Made-in-China" goods
now fill homes around the world.
But our giant country has a small problem. We
can't manufacture the happiness
of our people. (31)

———

[The Olympics are] an event manipulated
into misleading people into believing that we
have entered a new, successful and
harmonious period in our history. This
is not true. (22)

———

Today China and the world will meet again. People will see that the planet is now smaller than at any time in history, that mankind should bid farewell to arrogance and indifference, to ignorance and discrimination, and understand that we share the same small piece of land. It will be a time to rediscover each other, to share what is good in life, to look each other in the eye and link all ten fingers. (24)

On Art and Activism

Everything is art. Everything is politics. (35)

———

The art always wins. Anything can happen to
me, but the art will stay. (36)

———

Life is art. Art is life. I never separate it. I don't
feel that much anger. I equally have
a lot of joy. (37)

———

Creativity is part of human nature. It can only
be untaught. (38)

———

I think my stance and my way of life is my
most important art. (39)

———

It's never about me. [My supporters] use me
as a mark for themselves to recognize their
own form of life: I become their medium. I
am always very clear about that. (40)

———

"Why are you so concerned about society?"
That is always the question. And my answer is
simple: "Because you are an artist,
you have to associate yourself with freedom
of expression." (41)

———

I think it's a responsibility for any artist to protect freedom of expression and to use any way to extend this power. (42)

———

If there is no freedom of expression, then the beauty of life is lost. Participation in a society is not an artistic choice, it's a human need. (43)

———

My work has always been political, because the choice of being an artist is political in China. (44)

———

I think restrictions are an essential condition in the fight for freedom of expression. It's also a source for any kind of creativity. (43)

———

The Chinese authorities think of artists as prostitutes. And in reality it's true: in the Communist system artists just represent what the power structure seeks them to represent. It is prostitution. (22)

———

I think all aesthetic judgments—all
the aesthetic choices we are making—are
moral choices. They cannot escape the moral
dimension in the broader sense. It has
to relate to the philosophical understanding of
who we are and how so-called "art and
culture" functions in today's world. (44)

———

I came to art because I wanted to escape the
other regulations of the society. The whole
society is so political. But the irony
is that my art becomes more and more
political. (45)

———

My activism is a part of me. If my art has anything to do with me, then my activism is part of my art. (46)

———

I spend very little time just doing "art as art." (40)

———

To me, to be political means you associate your work with a larger number of people's living conditions, and that includes both mental and physical conditions. And you try to use your work to affect the situation. (44)

———

Being an artist is more of a mindset, a way of seeing things; it is no longer so much about producing something. (9)

———

It became like a symbolic thing, to be "an artist." After Duchamp, I realized that being an artist is more about a lifestyle and attitude than producing some product. (6)

I am very much interested in the so-called useless object. I mean, it takes perfect craftsmanship, beautiful material carefully measured and crafted, but at the same time it's really useless. (47)

———

Very few people know why art sells so high. I don't even know. (48)

———

Antiques exist as evidence of the cultural tracks we made in the past. (41)

———

I'm an artist who is always looking for what is possible. I'm always looking to extend the boundaries. (12)

———

I think art certainly is the vehicle for us to develop any new ideas, to be creative, to extend our imagination, to change the current conditions. (42)

———

I always want to design a frame that's open to everyone. I don't see art as a secret code. (49)

———

Art is always about overcoming obstacles between the inner condition and the skill for expression. (43)

———

My definition of art has always been
the same. It is about freedom of expression, a
new way of communication. It is never about
exhibiting in museums or about hanging it on
the wall. Art should live in the heart of
the people. Ordinary people should have the
same ability to understand art as anybody else.
I don't think art is elite or mysterious. I don't
think anybody can separate art from politics.
The intention to separate art from politics is
itself a very political intention. (50)

———

Contemporary art and the [Communist] Party
are an impossible situation. It's like oil and
water—they can never mix. (22)

———

The people who control culture in China have no culture. (51)

———

We see plenty of artistic work that reflects superficial social conditions, but very little work that questions fundamental values. (22)

———

To protect the right of expression is the central part of an artist's activity. . . . In China many essential rights are lacking, and I wanted to remind people of this. (28)

———

You need [to make] something people can realize is art. Otherwise they think you are too political. Sometimes you have to say: "Oh, I am an artist, you know. I can do this." (47)

———

I definitely know people who are shameless enough to give up basic values. I see this kind of art, and when I see it I feel ashamed. In China they treat art as some form of decoration, a self-indulgence. It is pretending to be art. It looks like art. It sells like art. But it is really a piece of shit. (37)

———

I don't have this concept that separates my art from my daily life. They are one thing to me. They are always one. How do you find the way to express yourself and how to communicate with others? (42)

———

Myself, I try to search for the new way, always trying to set up a new possibility and to find the new tools to express myself. To reach a broader audience. (14)

———

I'm not sure I'm good at art, but I find an escape in it. (52)

I think by shattering it we can create a new
form, a new way to look at what is valuable—
how we decide what is valuable. (14)

———

Art is not an end but a beginning. (23)

On Government,
Power, and Making
Moral Choices

Once you've tasted freedom, it stays in your heart and no one can take it. Then, you can be more powerful than a whole country. (8)

———

I don't feel powerful at all. I am still under this kind of detention, and you know, this is kind of a bail. Even yesterday I realized while trying to take care of the baby, [at] the park, [I had] been secretly followed and it's quite fragile. Maybe being powerful means to be fragile. (42)

———

I have the responsibility to let the people
know what happened to me, and did I
commit the crime or if I didn't, what is the
real accusation? Why am I in this condition
today? I think it reflects our human condition
in this piece of land, and if I don't bear some
responsibility many, many people, their
voice can never be heard. (29)

———

I feel powerless all the time, but I regain my
energy by making a very small difference that
won't cost me much. (38)

———

In China, there is a long history of the government not revealing information, so it's difficult for the Chinese people to ever know the truth. It is vital that we try to bring that truth to life. (53)

———

Because of the economic crisis, China and the United States are bound together. This is a totally new phenomenon, and nobody will fight for ideology anymore. It's all about business. (28)

———

What does it matter if China's economy grows when there are no basic protections for its citizens? (53)

———

Behind every political deal in this country, the first casualties are always the ordinary people, who are barely treated as human. (10)

———

They [the government] really want to maintain power. At the same time, they refuse to communicate. They refuse to have good intentions. They refuse to be sincere. How can that last? (12)

———

There is no revolution like the Communist revolution. You simply burn all the books, kill all of the thinking people and use the poor proletariat to create a very simple benchmark to gauge social change. (22)

———

China has not established the rule of law and thus there is no justice. (11)

They don't believe in liberty. They don't believe in China before the Communists. There is only one simple, clear task: to protect their control, to maintain their governing. Which is such a pity. (45)

The great success of this system is that it makes the general public afraid of taking responsibility, afraid of taking a position or giving a definite answer, or even of making mistakes. (22)

They have to have an enemy. They have to create you as their enemy in order for them to continue their existence. It's very ironic. (54)

———

They know too many things they should not know and they do not know some things they need to know. (55)

———

Not an inch of the land belongs to you, but every inch could easily imprison you. (9:10 a.m. May 21, 2010; 4)

———

The officials want China to be seen as a cultured, creative nation, but in this anti-liberal political society everything outside the direct control of the state is seen as a potential threat. (51)

———

The government may be made up of clever, sensible people. But if they do not believe in basic human values, the more clever or shrewd they are the greater the tragedy they will create. (22)

———

It is better to have a retarded president who respects human values than a clever government without human values. (22)

———

Any power or structure that seeks to maintain
full control and is not open in any way to
loosening its power eventually makes
itself ridiculous. (22)

———

Police in China can do whatever they want;
after 81 days in arbitrary detention you clearly
realise that they don't have to obey
their own laws. (51)

———

In a society like this there is no negotiation,
no discussion, except to tell you that power
can crush you any time they want—not only
you, your whole family and all people
like you. (56)

———

We need clear rules to play the game.
We need to have respect for the law. If you
play a chess game but after two or three
moves you can change the rules, how can
people play with you? Of course you will win,
but after 60 years you will still be a bad player
because you never meet anyone who can
challenge you. What kind of game is that? Is
that interesting? This game is not
right, but who is going to say,
"Hey, let's play fairly?" (12)

———

They detained me for 81 days, but
they never killed me. They clearly told me:
"If we were in the Cultural Revolution, you
would have been killed 100 times." They said:
"We have already improved." I said: "I thank
you very much. Yes, you have improved.
Not because you are really willing to improve
yourself, but only because improvement is a
matter of surviving." (37)

———

[My family] suffer so much.

My mother was much older when I came
out [of detention]. She had problems with her
hearing and high blood pressure. But they
still support me. When you make somebody
disappear and you don't announce it to the
family, what is this? You make people
desperate and bring them close to death. If
our cat or dog is lost, it makes us desperately
want to know where it is—so for humans
disappearing, you can barely imagine the pain.

What kind of society is this? If a society
cannot even support somebody like me, then
people ask: Who is under protection,
then? That's why there is such support for me.
It is not because I am so beautiful or so
charming. People feel, This guy
is fighting for us. (36)

———

Tips on surviving the regime: Respect yourself
and speak for others. Do one small
thing every day to prove the existence of
justice. (12:39 p.m. August 6, 2009; 4)

———

A city is a place that can offer maximum
freedom. Otherwise it's incomplete. (57)

———

Cities really are mental conditions. Beijing is a
nightmare. A constant nightmare. (57)

———

Beijing is two cities. One is of power and of money. People don't care who their neighbors are; they don't trust you. The other city is one of desperation. I see people on public buses, and I see their eyes, and I see they hold no hope. They can't even imagine that they'll be able to buy a house. They come from very poor villages where they've never seen electricity or toilet paper. (57)

———

Three years after the CCTV headquarters fire [in Beijing in February 2009], human skeletons lie forgotten. Is anyone accountable?

(7:41 a.m. February 23, 2012; 58)

———

The worst thing about Beijing is that
you can never trust the judicial system.
Without trust, you cannot identify anything;
it's like a sandstorm. You don't see yourself as
part of the city—there are no places that you
relate to, that you love to go. You have no
memory of any material, texture, shape.
Everything is constantly changing, according
to somebody else's will,
somebody else's power. (57)

ON THE 2008 SICHUAN EARTHQUAKE:

From my experience dealing with Sichuan
[after the 2008 earthquake] I started to
understand very clearly the character of local
government. They will do anything. You will
never really wrongly accuse them of anything
because they do everything. (59)

———

The disaster-makers always get away, while the
innocent are always punished. (10)

———

Once again, the facts have been erased. (10)

———

When the mayor of Nagoya denies the
Nanjing Massacre, he gets blacklisted by the
city of Nanjing. When the government of
Sichuan denies "tofu dregs" construction
[which caused the collapse of several
schools], they get blacklisted
by me. (5:12 p.m. February 21, 2012; 60)

———

I am always trying to find how to get
the message through. [In Munich] we
custom-made five thousand backpacks like the
ones of those students [who died in Sichuan]
to construct a simple sentence [spoken
by the] mother of a dead student. It was: "She
has been happily living in this
world for seven years." (14)

———

The Sichuan disaster is not the first nor the most wrongful. But all the details of this tragedy will be forgotten, and once again it will be like nothing ever happened. Eventually all these disasters will together create a bizarre miracle called civilization and evolution. (10)

———

The Chinese [government] only superficially speaks the language of the international community. (22)

———

Cover-ups and deception are the nature of this society. Without lies it won't exist. (10)

———

No autocracy can lead people to believe that they are living in harmony and happiness. (61)

———

Consider why the quality of school dinners is declining, even as more and more golf courses are opened. (34)

———

This is a decadent era. Its main characteristic is that it's dependent on lies and cheating. Once it loses this characteristic, it can't survive for even a day.

(4:16 p.m. February 21, 2011; 62)

———

A society that has no ideals, that discards the principles of humanitarianism, that abandons the fundamental rights and dignity of humanity, can only survive by denying truth, fairness and justice. (10)

———

One of the reasons religions are widely accepted is spiritual laziness and its resulting fear. (6:10 a.m. December 24, 2010; 63)

———

I think the government [will] lose
the battle. Because for a nation to develop, the
government needs to correct the information,
they need to have a space for people to be
involved, to discuss, to participate in the
change. Otherwise, I don't think they can
really last in this kind of development,
because economically it goes so fast but
politically it stays the same as many, many
years ago. I think even the government senses
that this is impossible. (64)

———

I think China is in a chaos now and it could be more chaos. It's an orderly chaos. It's a party that ruthlessly violates every human's basic rights to serve its own purpose. (13)

———

They just don't trust people. They don't trust individuals, they don't trust any change that should serve and benefit people, and they try to stop it. (13)

———

The state is taking action against people who have peacefully demonstrated their ideas. They are writers—all they did is to express their minds through the Internet. So the pattern is very clear. The state tries to maintain stability by crushing any thought of making change. It could happen to me, because I did the same thing and in many cases I went much further and deeper. But I always think the government can learn from their mistakes—they should learn and understand; they should be just as intelligent as anyone else. (27)

———

You see a Party system that crushes down anybody who [has] different opinions, who has different ideas in their mind. Simply to have different opinions can cost someone their life. They can be put in jail, they can be silenced, and they can [disappear]. And the other people would take it, not giving support. (14)

———

I want to prove that the system is not working. . . . You can't simply say that the system is not working. You have to work through it. (39)

———

The frustration mainly comes from trying to understand what they really want. Also, you cannot understand how can such a large nation maintain its so-called stability by doing something very unlawful. I mean, how can they possibly manage to stabilize the whole social condition by not [acting with] justice and fairness. (29)

———

I have no sense of why I lost my freedom and if you do not know how you lost something, how can you protect it? (11)

———

Tax crimes should be investigated
by the tax bureau, not through secret police
detention. (56)

The only reason they put me in jail
is my involvement in politics, my criticism of
the authorities. Later the excuse for my
detention became my "tax problem." But
internally they never told me anything about
it. I don't want to underestimate their
intelligence, but up to this day I think what
they did is very stupid. In fact, they even
helped me in an ironic sense. They
gave me a chance to explain what is
happening with this system. They provided
such a platform for me. (50)

In a society where there is no freedom
of the press, it is difficult for victims to be
noticed. Just take the example from yesterday:
I had given a telephone interview to CNN.
Then, suddenly, CNN was shut down for a
couple of minutes. It was the first time I
experienced that my television went totally
dead. I realized: Oh my God, it's because of
me. This is crazy! Which nation would
do that? Maybe Cuba, North Korea, China.
But what do they want, what are
they so afraid of? (50)

———

Do they want me to stay? Do they want
me to leave? Do they want me to hang myself?
To kill myself? What do they want? (37)

———

The 81 days of detention were a nightmare. I am not unique; it happened to many people in China. Conditions were extreme, created by a system that thinks it is above the law and has become a kind of monstrous machine. There were so many moments when I felt desperate and hopeless. But still, the next morning, I heard the birds singing. (11)

———

[People] always tell me, "Weiwei, leave the nation, please." Or "Live longer and watch them die." Either leave, or be patient and watch how they die. I really don't know what I'm going to do. (57)

———

Choices after waking up: To be true or to lie?
To take action or be brainwashed? To be free
or be jailed? (7:06 p.m. September 4, 2009; 65)

———

Life is never guaranteed to be safe, so we
better use it while we are still in good
condition. (27)

On the Digital World

Only with the Internet can a peasant
I have never met hear my voice and I can learn
what's on his mind. A fairy tale has come
true. (66)

———

The Internet is uncontrollable. And if the
Internet is uncontrollable, freedom will win.
It's as simple as that. (17)

———

The Internet is the best thing that could have
happened to China. (61)

———

On the Internet, people do not know
each other, they don't have common leaders,
sometimes not even a common political goal.
But they come together on certain
issues. I think that is a miracle. It never
happened in the past. Without the Internet,
I would not even be Ai Weiwei
today. I would just be an artist somewhere
doing my shows. (50)

———

No outdoor sports can be more elegant
than throwing stones at autocracy; no melees
can be more exciting than those in
cyberspace. (8:03 a.m. March 10, 2010; 4)

———

Neither fairness nor justice, neither reality nor
humanity can be simulated or manipulated by
wires or remote controls. (31)

———

The government computer has one button:
delete. (67)

My blog is an extension of my thinking. Why should I deform my thinking simply because I live under a government that espouses an ideology which I believe to be totally against humanity? (22)

———

Block [my blog] if you want, but I cannot self-censor, because that is the only reason I have the blog. We both know this is a game. You have to play your part, and I have to play mine. (33)

———

Before blogging, I was living in the Middle Ages. Now my feelings for time and space are entirely different. (66)

———

Chairman Mao was the first in the world to use Twitter. All his quotations are within 140 words. (66)

———

[With] 140 words in Chinese, you really can write a novel. Most of Confucius's sentences [are] only four words, so 140 words [might] take his whole life to write. And you can discuss the most profound ideas related to democracy, freedom, poetry. (13)

———

Twitter is the people's tool, the tool of the ordinary people, people who have no other resources. (68)

———

If Shakespeare were alive today, he might be writing on Twitter. (39)

———

As an artist, I am very familiar with how to show the details, how to transform them into a language people can understand. They [the government] know that the Internet is a strong force, unbearable for them. (50)

———

People often say I started to become too outspoken after a certain period. It's all because of the Internet. If we didn't have this technology I would be same as everybody else. I couldn't really amplify my voice. (27)

———

On History,
the Historical Moment,
and the Future

I see myself not as a leader but as somebody who initiates things or finds the problem or provokes a discussion. You have to be always ready to engage, willing to participate. When events or history happen, you just have to be aware and respond. (38)

———

If a nation cannot face its past, it has no future. (50)

———

We need to get out of the old language. (41)

———

The language of communication will always need to be renewed. (41)

———

To what degree does it help us to change our life, or even to sense our existence, to really evaluate "why?" I think those questions cannot be escaped. Sometimes in history it's more hidden; somewhere these can be very personal and individual questions. But in certain times and certain places, your existence has to be associated with other people's situations. You have to make a reaction to the living conditions. It's not avoidable. You cannot just be blind about what is happening there.

Such is the case in China. (44)

———

In talking about memory and our history, I think our humanity, especially in China, is cut. Cut, broken, separated. If we have a character from our history and memory, the character is broken, it's shattered. (44)

———

Tradition is only a readymade. It's for us to make a new gesture—to use it as a reference, more as a starting point than conclusion. Of course, there are very different attitudes and interpretations about our past and our memory of it. And ours is never a complete one, but is broken. In China, but also in my practice. (44)

———

Modernism represents a true kind
of living. Modernism is not about form or
method or the works of a few artists, but
rather about a necessary way of living.
And only this kind of lifestyle can save China,
because if we don't have modernism, then we
will die under the grasp of one or
another ideology. Modernism at least says that
every person is free and needs to honestly
encounter his own life. (33)

The world is a sphere, there is no
East or West. (69)

I think strategically China has come to
a very crucial moment. They [the
government] have to re-justify themselves.
Even the past 20 to 30 years are based on a
kind of destructive, suicidal act. Now they are
trying to reach a higher level, but I think in
any society, culture should have its
own rights: not to be touched by the
government, not to be promoted by the
government, also not to be destroyed by
the government. (70)

———

I think right now is the moment. This is the beginning. We don't know what is it the moment of, and maybe something much crazier will happen. But really, we see the sunshine coming in. It was clouded for maybe a hundred years. Our whole condition was very sad, but we still feel warmth, and the life in our bodies can still tell that there is excitement in there, even though death is waiting. We had better not enjoy the moment, but create the moment. (71)

———

During my detention, they kept asking me: Ai Weiwei, what is the reason you have become like this today? My answer is: First, I refuse to forget. My parents, my family, their whole generation and my generation all paid a great deal in the struggle for freedom of speech. Many people died just because of one sentence or even one word. Somebody has to take responsibility for that. (50)

———

I try to encourage people to look at our past in a critical way because as our education, we have a great, great history. But in reality we are poorest in ethics and philosophy, so I try to raise people's consciousness on how we deal with our past. (14)

———

I think I have this responsibility to my father's generation, and especially future generations. (26)

———

I don't want the next generation to fight the same fight as I did. (8)

———

The population is in a constant state of enforced dislocation. So let us hope that a totally new culture will come out of this. (22)

———

Imagine one day, the hateful world around you collapses. And it is your attitude, words and actions that put an end to it. Will you be excited? (8:25 a.m. August 28, 2009; 4)

––––––

China might seem quite successful in its controls, but it has only raised the water level. It's like building a dam: it thinks there is more water so it will build higher. But every drop of water is still in there. It doesn't understand how to let the pressure out. It builds up a way to maintain control and push the problem to the next generation. (17)

––––––

My current situation is, I always want
to find a new possibility. China is in a
changing stage, and that puts me in a very
difficult situation, because anytime a new
condition is announced there is a lot of
struggle between the new and the old. So the
establishment really becomes extremely
nervous because they are refusing to meet
very basic human rights or values. I don't
know how long I can still struggle in
China, but I will try my best. Because this is a
land I am very familiar with, and
we have been in the same kind of struggle
for generations. I think it's a
time for change. (64)

———

You can see China still cannot offer any real value to the world except as cheap labor, manufacturer, and its own so-called stability. Besides that, I don't see any creative values and creative mind or thinking [that] can be announced from China. So this is the struggle China has to face in the next decades. (27)

―――

People have said, if you leave, you may never come back. Or they may not even let you leave. So this is always a cost you may have to pay. But I don't want to restrict myself: When it happens, it happens. I have to deal with it, but not to prepare for it, because it is a kind of stupidity. If you prepare for it too much, you become a part of it. (27)

―――

It doesn't matter where I am—China will stay in me. I don't know how far I can still walk on this road and what is the limit. (50)

———

I will never leave China, unless I am forced to. Because China is mine. I will not leave something that belongs to me in the hands of people I do not trust. (15)

———

I don't know about five years from now. I have no plans for that. Maybe I'll be forgotten by then. (23)

Personal Reflections

I've never planned any part of my career—except being an artist. And I was pushed into that corner because I thought being an artist was the only way to have a little freedom. (38)

———

Later I became very involved in writing. I really enjoyed that moment of writing. People would pass around my sentences. That was a feeling I never had before. It was like a bullet out of the gun. (12)

———

Anyone fighting for freedom does not want to totally lose their freedom. (28)

———

I always have an attitude. Even if there
are no plans, I have an attitude. Perhaps I
answered imprecisely before, saying that I am
just a person. I am actually a person
with an attitude. (72)

———

Expressing oneself is like a drug. I'm so
addicted to it. (66)

———

I don't really care that much about if I want to
be more successful or less successful in art,
because I never think life and art should be
separate. What's life if you don't have
conversation and joy and anger? (26)

———

Overturning police cars is a super-intense workout. It's probably the only sport I enjoy.

(6:46 p.m. June 15, 2009; 4)

When I returned to China [from the United States], I didn't have a U.S. passport, a wife, or a university degree. From the Chinese point of view, I was a total failure. (41)

I loved New York—every inch of it. It was a
little bit scary at that time, but still,
the excitement was so strong—visually and
intellectually. It was like a monster. (27)

———

When I checked into a hospital [in Germany,
after having been beaten by police in
Sichuan], I was told there was bleeding in my
brain and I was near fatal collapse. I was
rushed into surgery. When I awoke I felt like a
normal person again. But I will not feel whole
until I and my fellow Chinese
can live freely. (53)

———

I wouldn't say I've become more radical: I was born radical. (49)

———

I often think what I'm saying is for the people who never had a chance to be heard. (41)

———

I think we have too much history. It's not so important. I think people should have fun and enjoy their own time. I haven't done much, so why should I waste people's memory? (28)

ON HIS EIGHTY-ONE-DAY DETENTION:

Nothing. Jail is about nothing.
Completely blank. (37)

———

This is something you can never erase. It
leaves a scar on you. (37)

———

You're in total isolation. And you don't
know how long you're going to be there, but
you truly believe they can do anything to you.
There's no way to even question it. You're not
protected by anything. Why am I here? Your
mind is very uncertain of time. You become
like mad. It's very hard for anyone. Even for
people who have strong beliefs. (57)

———

It's really life and death [not art]. When
they tell you your mother is 80 years old but
you cannot see her again, you can never call it
performance art. Or when your son is three,
and they tell you that when you are released
he will be in his teens and can never
recognize you as a father. You feel terrible
inside, to lose those chances. Each day, they
tell you, "You will spend your life day
after day the same, minute after minute the
same. You just have to pay [with] your life for
this kind of so-called freedom that you
are fighting for." There is no sense of justice
there. Why do I have to do this
with them? Why do I have to argue
or play this game? (29)

I lost all connection with the outside world and was immersed in a world of darkness. I was scared that my existence would fade silently. No one knew where I was, and no one would ever know. I was just like a small soybean—once fallen to the ground, it rolls into a crack in the corner. Being unable to make any sounds, it will forever be forgotten. (73)

———

It's hard to recover. You become not so innocent. You become, in a way, more sophisticated, which I think you shouldn't. We should all have more simple happiness You become bitter. (26)

———

Maybe there is something I got from it. Maybe you also start to be clear on certain things. (26)

———

Every day I think, this will be the day I get taken in again (26)

———

I often ask myself if I am afraid of being detained again. I love freedom as much as anybody else, maybe more than most. But it is a tragedy to live your life in fear. It is worse than actually losing your freedom. (11)

———

During the days in detention, I thought most about the moon. (6:26 a.m. December 10, 2011; 74)

———

ON THE CONTRIBUTIONS SENT BY CHINESE CITIZENS TOWARD PAYING THE TAX BILL LEVIED BY THE GOVERNMENT:

There were thousands of moving messages.
People sent money from their first month's
salary. Others said: This is my retirement
payment—take it. This is the money for my
next pair of shoes—take it. It was very
important for me to see and hear those things.
Normally you do not see the warmth, humor,
care and generosity of the people while
writing a blog. You just feel like you
are walking in a dark tunnel and you
feel alone. (50)

———

Nothing can silence me as long as I am alive. I don't give any kind of excuse. If I cannot come out [of China] or I cannot go in [to China] this is not going to change my belief. But when I am there, I am in this condition: I see it, I see people who need help. Then you know, I just want to offer my possibility to help them. (13)

SOURCES

1. Ai Weiwei. *Ai Weiwei's Blog: Writings, Interviews, and Digital Rants, 2006–2009*. Translated by Lee Ambrozy. Cambridge, MA: MIT Press, 2011.

2. McLaughlin, Kathleen. "Meet the Most Interesting Person in China." *Global Post*, June 23, 2009. http://www.globalpost.com/dispatch/china-and-its-neighbors/090623/meet-the-man-who-wants-shut-down-the-internet-china?page=0,0

3. Ai Weiwei and Mark Siemons. *Ai Weiwei: So Sorry*. New York: Prestel, 2009. Exhibition catalog.

4. Ai Weiwei Twitter feed: @Aiww

5. "Artist Ai Weiwei: China Crushes Dissenting Voices," *Fox News*, June 11, 2012. http://www.foxnews.com/world/2012/06/11/artist-ai-weiwei-china-crushes-dissenting-voices/

6. Smith, Karen, Hans Ulrich Obrist, Bernard Fibicher, and Ai Weiwei. *Ai Weiwei*. Phaidon Contemporary Artists Series. London: Phaidon Press, 2009.

7. Ai Weiwei, interview for The Unilever Series—Ai
 Weiwei: Sunflower Seeds at Tate Modern, October
 12, 2010. http://www.tate.org.uk/context-comment
 /video/ai-weiwei-conversation

8. *Ai Weiwei: Never Sorry.* Documentary film directed by
 Alison Klayman. Produced by Expression United
 Media in association with MUSE Film and Televi-
 sion, 2012.

9. Hickley, Catherine. "Ai Weiwei, Nursing Head Wound,
 Sharpens Criticism: Review." Bloomberg, October
 14, 2009. http://www.bloomberg.com/apps/news?pid
 =newsarchive&sid=ac5W2eD3vmD4

10. Ai Weiwei. "Our Duty Is to Remember Sichuan."
 Guardian, May 25, 2009. http://www.guardian.co.uk
 /commentisfree/2009/may/25/china-earthquake-cover
 -up/print

11. Ai Weiwei. "To Live Your Life in Fear Is Worse Than
 Losing Your Freedom." *Guardian*, June 21, 2012.
 http://www.guardian.co.uk/commentisfree/2012
 /jun/21/ai-weiwei-living-life-fear-freedom

12. Beech, Hannah, and Austin Ramzy. "Ai Weiwei: The Dissident." *Time*, December 14, 2011. www.time .com/time/specials/packages/article/0,28804,2101745 _2102133_2102331,00.html

13. Ai Weiwei, "Digital Activism in China." Conversation with Jack Dorsey and Richard MacManus at The Paley Center for Media, New York City, March 15, 2010. http://www.paleycenter.org/special-event-ai -weiwei-jack-dorsey-richard-macmanus/

14. Ai Weiwei, interview by Christiane Amanpour, CNN. YouTube video, uploaded by asianrapworldwide, March 21, 2010. http://www.youtube.com/watch?v =xyAeLmN_UjA; http://www.youtube.com/watch?v=rC go6b6bqqQ&feature=related

15. Wee, Sui-Lee. "Ai Weiwei Says Blind Dissident's Escape Will Inspire Chinese." Reuters, May 29, 2012. http://www.reuters.com/article/2012/05/29 /us-china-artist-idUSBRE84S0A120120529

16. Higgins, Charlotte. "Ai Weiwei: 'China in many ways is just like the middle ages.'" *Guardian*, April 11,

2011. http://www.guardian.co.uk/artanddesign/2011
/apr/11/ai-weiwei-china-last-interview

17. Ai Weiwei. "China's Censorship Can Never Defeat the
Internet." *Guardian*, April 15, 2012. http://www
.guardian.co.uk/commentisfree/libertycentral/2012
/apr/16/china-censorship-internet-freedom

18. AFP. "China Artist Ai Weiwei Says Regrets Bird's Nest."
March 15, 2012. http://www.google.com/hostednews
/afp/article/ALeqM5gOUb-RbjpH0QOU4rY___aZPTaBW
Q?docId=CNG.7ce214ed2bf910d9d222c782a5fc5c3e.4c1

19. https://twitter.com/aiww/status/24295316865941504

20. https://twitter.com/aiww/status/12868663606509568

21. "House Arrest in China: Orwell, Kafka, and Ai
Weiwei." *Economist*, April 13, 2012. http://www
.economist.com/blogs/analects/2012/04/house
-arrest-china

22. Kirby, Simon. "Truth to Power." *Index on Censorship*
37:2 (May 2008), 20–34. http://www.indexoncensor-
ship.org/wp-content/uploads/2008/12/ai-weiwei_a
_309689.pdf

23. Hsieh, Catherine Yu-Shan. "Ai Weiwei: A Rebel of
Poet Roots." *NY Arts*, March–April 2008. http://

www.nyartsmagazine.com/conversations/ai-wei-wei-a-a
-a-rebel-of-poet-roots

24. Ai Weiwei. "Why I'll Stay Away from the Opening
Ceremony of the Olympics." *Guardian*, August 7,
2008. http://www.guardian.co.uk/commentisfree
/2008/aug/07/olympics2008.china

25. Ai Weiwei blog on sina.com

26. Branigan, Tania. "Ai Weiwei: 'Every day I think, this
will be the day I get taken in again '" *Guardian*,
November 25, 2011. http://www.guardian.co.uk
/artanddesign/2011/nov/26/ai-weiwei-china
-situation-quite-bad

27. Branigan, Tania. "Ai Weiwei: 'I have to speak for
people who are afraid.'" *Guardian*, March 17, 2010.
http://www.guardian.co.uk/artanddesign/2010/mar
/18/ai-weiwei-turbine-hall-china

28. "Who Is Ai Weiwei?" *Artinfo*, August 11, 2009.
http://www.artinfo.com/news/story/32223/who-is
-ai-weiwei/?page=1

29. Ai Weiwei, "You're There but You're Not Existing."
Interview by Jian Ghomeshi, *Q*, CBC Radio Canada,

March 22, 2012. http://www.cbc.ca/q/news_promo /2012/03/22/ai-weiwei-on-q/

30. Watts, Jonathan. "Chinese Human Rights Activist Liu Xiaobo Sentenced to 11 Years in Jail." *Guardian*, December 25, 2009. http://www.guardian.co.uk /world/2009/dec/25/china-jails-liu-xiaobo

31. Ai Weiwei. "Happiness Can't Be Faked." *Guardian*, August 18, 2008. http://www.guardian.co.uk /commentisfree/2008/aug/18/china.chinathemedia

32. Baecker, Angie, and Graham Webster. "Beijing before the Olympics: Business as Usual?" *Art Asia Pacific*, July/August 2008. http://artasiapacific.com/Magazine /59/BeijingBeforeTheOlympicsBusinessAsUsual

33. Tinari, Philip. "A Kind of True Living." *Artforum*, Summer 2007, 453–459.

34. Ai Weiwei. "Gold Is Not the Real Measure of a Nation." *Guardian*, August 25, 2008. http://www .guardian.co.uk/commentisfree/2008/aug/25 /olympics2008.china

35. Coonan, Clifford. "An Artist's Struggle for Justice in China." *Independent*, February 27, 2010. http://www

.independent.co.uk/news/world/asia/an-artists-struggle
-for-justice-in-china1912352.html

36. "Ai Weiwei: Artistic Licence." *Economist*, May 5, 2012.
http://www.economist.com/node/21554178

37. "Ai Weiwei: 'Shame on Me.'" Part 2: "Do They Want
Me to Leave?" *Der Spiegel*, November 21, 2011.
http://www.spiegel.de/international/world/ai-weiwei
-shame-on-me-a-799302-2.html

38. Larmer, Brook. "Life's Work: Ai Weiwei." *Harvard
Business Review*, April 6, 2012. http://hbr.org/2012
/04/ai-weiwei/ar/1

39. Osnos, Evan. "It's Not Beautiful: An Artist Takes On
the System." *New Yorker*, May 24, 2010, 54–63.
http://www.newyorker.com/reporting/2010/05/24
/100524fa_fact_osnos?currentPage=all

40. Jones, Alice. "Ten People Who Changed the World: Ai
Weiwei, Chinese Artist, Became a Truly Global
Force." *Independent*, December 31, 2011. http://www
.independent.co.uk/arts-entertainment/art/features
/ten-people-who-changed-the-world-ai-weiwei-chinese
-artist-became-a-truly-global-force-6282327.html

41. Frazier, David. "Truth to Power: Ai Weiwei's Public Discontent Is an Anomaly in the No-Politics World of Chinese Contemporary Art." *Taipei Times* online, August 16, 2009. http://www.taipeitimes.com/News/feat/archives/2009/08/16/2003451249

42. "Ai Weiwei 'Does Not Feel Powerful.'" BBC, October 13, 2011. http://www.bbc.co.uk/news/entertainment-arts-15288035

43. Solway, Diane. "Enforced Disappearance." *W Magazine*, November 2011.

44. Worrall, Julian. "Escape from Propaganda." *Japan Times*, July 31, 2009. http://search.japantimes.co.jp/cgi-bin/fa20090731a1.html

45. Wines, Michael. "China's Impolitic Artist, Still Waiting to Be Silenced." *New York Times*, November 28, 2009. http://www.nytimes.com/2009/11/28/world/asia/28weiwei.html?pagewanted=all

46. Frazier, David. "Ai Weiwei's Year of Living Dangerously." *Art in America*, September 2009, 28.

47. Ai Weiwei, interview in "Change," Episode 1, Season Six, Art: 21—*Art in the Twenty-First Century*, PBS, April

2012. http://www.pbs.org/art21/watch-now/episode
-change

48. Wong, Edward. "First a Black Hood, Then 81 Captive
 Days for an Artist in China." *New York Times*, May 26,
 2012. http://www.nytimes.com/2012/05/27/world
 /asia/first-a-black-hood-then-81-captive-days-for-artist
 -in-china.html?_r=2&ref=todayspaper

49. *Ai Weiwei: Sunflower Seeds*. Ed. Juliet Bingham. The
 Unilever Series. London: Tate Publishing, 2010.
 Exhibition catalog.

50. "Ai Weiwei: 'Shame on Me.'" *Der Spiegel*, November
 21, 2011. http://www.spiegel.de/international/world
 /ai-weiwei-shame-on-me-a-799302.html

51. Anderlini, Jamil. "China's 'Mozart' Drops Off State
 Hit Parade." CNBC.com, May 12, 2010. http://www
 .cnbc.com/id/37107939/

52. Barboza, David, and Lynn Zhang. "The Clown
 Scholar: Ai Weiwei." *ArtzineChina*, 2008. http://www
 .artzinechina.com/display.php?a=180

53. Ai Weiwei. "An Artist's Ordeal." *Newsweek*, November 11, 2009. http://www.thedailybeast.com/newsweek/2009/11/12/my-ordeal.html

54. "Ai Weiwei Talks Revolution, Shanghai Studio in New Time Out: HK." *Time Out: Hong Kong*, March 14, 2011. http://shanghaiist.com/2011/03/14/ai_weiwei_talks_revolution_shanghai.php

55. Moore, Malcolm. "Ai Weiwei: 'The police can be very tough, but I can be tougher sometimes.'" *Telegraph*, May 30, 2012. http://www.telegraph.co.uk/culture/art/art-features/9299885/Ai-Weiwei-The-police-can-be-very-tough-but-I-can-be-tougher-sometimes.html

56. Anderlini, Jamil. "At home: Ai Weiwei." *Financial Times*, February 24, 2012. http://www.ft.com/intl/cms/s/2/6fdcaae6-5959-11e1-abf1-00144feabdc0.html#axzz1nQPAYr26

57. Ai Weiwei. "The City: Beijing." *Newsweek*, August 28, 2011. http://www.thedailybeast.com/newsweek/2011/08/28/ai-weiwei-on-beijing-s-nightmare-city.html

58. https://twitter.com/aiww/status/172707557331320832

59. Branigan, Tania. "Accounts Invaded, Computers Infected—Human Rights Activists Tell of Cyber Attacks." *Guardian*, January 14, 2010. http://www.guardian.co.uk/world/2010/jan/14/china-human-rights-activists-cyber-attack

60. https://twitter.com/aiww/status/172126675054755840

61. Ai Weiwei. "The Olympics Are a Propaganda Show." *Spiegel*, January 29, 2008. http://www.spiegel.de/international/world/0,1518,531883,00.html

62. https://twitter.com/aiww/status/39840882052046848

63. https://twitter.com/aiww/status/18307573602058240

64. Ai Weiwei, "In China, Is Censorship the Mother of Creativity?" Interview on *The Stream*, Al Jazeera, April 16, 2012. http://stream.aljazeera.com/story/china-censorship-mother-creativity-0022167?utm_content=automate&utm_campaign=Trial6&utm_source=NewSocialFlow&utm_term=plustweets&utm_medium=MasterAccount

65. https://twitter.com/aiww/status/3770858785

66. Jiang Xueqing. "The Bold and the Beautiful." *Global Times*, November 26, 2009. http://special.globaltimes.cn/2009-11/488006.html

67. Zhang, Qichen. "Ai Weiwei Says Censorship in China Will Ultimately Fail." *Opennet*, April 18, 2012. http://opennet.net/blog/2012/04/ai-weiwei-says-censorship-china-will-ultimately-fail

68. Ventura, Catherine. "Is Twitter a Human Right? One Chinese Activist Thinks So." *Huffington Post*, March 17, 2012. http://www.huffingtonpost.com/catherine-ventura/is-twitter-a-human-right_b_501971.html

69. "No Fake: An Interview with Ai Weiwei." *Portland Art*, September 8, 2010. http://www.portlandart.net/archives/2010/08/no_fake_an_inte.html

70. Gill, Chris. "Ai Weiwei: 'To use art is not enough.'" *Art Newspaper*, December 3, 2009. http://www.theartnewspaper.com/articles/"To-use-art-is-not-enough"/19818

71. Tinari, Philip, and Angie Baecker, eds. *Hans Ulrich Obrist: The China Interviews*. Beijing: Office for Discourse Engineering, 2009.

72. Sans, Jerome. *China Talks: Interviews with 32 Contemporary Artists*, p. 9. Beijing: Timezone8, 2009.

73. Wong, Veronica, and Gisela Sommer. "Ai Weiwei Describes Mental Torment in Captivity." *Epoch Times*, August 3, 2011. http://www.theepochtimes.com/n2/china-news/ai-weiwei-describes-mental-torment-in-captivity-59915.html

74. https://twitter.com/aiww/status/145509774694432768

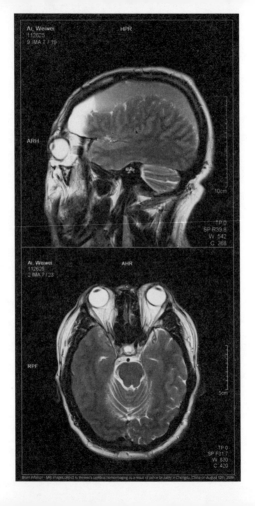

CHRONOLOGY

1957

May 18: Ai Weiwei is born to Ai Qing, one of China's
most revered modern poets, and his wife Gao Ying.

Ai Qing is denounced in the Anti-Rightist Campaign.
Over the next several years, he and his family are exiled to a series of labor camps in the far north.

1975

Ai Qing and his family are permitted to return to Beijing.

1978

Ai Qing is publicly exonerated.

Ai Weiwei enrolls in the Beijing Film Academy.

Bored and discontented at the academy, Ai Weiwei joins
Xing Xing (The Stars), one of the first avant-garde
contemporary art groups to emerge in post-Mao
China.

1979

Ai Weiwei participates in the first Stars exhibition, an
impromptu show mounted on the fence outside the
National Art Museum in Beijing.

1981

Ai Weiwei leaves China. He spends the next twelve years
in the United States, primarily in New York City.

1993

With Ai Qing's health in decline, Ai Weiwei returns to
China.

Participates in *The Stars: 15 Years*, a group show at Tokyo
Gallery, Tokyo.

1994–97

Ai Weiwei edits and publishes a series of books on con-
temporary Chinese art that becomes a foundation for
subsequent scholarship in the field: *Black Cover Book*
(1994), *White Cover Book* (1995), and *Gray Cover Book*
(1997).

1998

Cofounds the China Art Archives and Warehouse (CAAW), a contemporary art gallery and archive, for which he serves as artistic director.

1999

Designs and builds his first architectural project: a home-studio complex for himself in the Caochangdi district of Beijing.

Sets up architectural practice in response to unsolicited demand for his designs.

Participates in 48th Venice Biennale.

2000

Cocurates Fuck Off, a controversial exhibition of cutting-edge contemporary Chinese art in Shanghai.

Designs and builds headquarters for CAAW.

2003

Establishes his architecture and design firm, FAKE Design.

Begins collaboration with Swiss architects Herzog & de
 Meuron on proposal for Beijing National Stadium
 ("Bird's Nest") for the 2008 Olympics.
Completes Jinhua Ai Qing Cultural Park and Yiwu River-
 bank in Jinhua, Zhejiang Province.

2004

Designs the restaurant Go Where? in Beijing.
Participates in 9th Venice Biennale of Architecture.
Participates in *Between Past and Future: New Photogra-*
 phy and Video from China, a group show that tours
 internationally.

2005

Participates in 2nd Guangzhou Triennial.
Begins blogging on sina.com.

2006

Participates in Davos World Economic Forum Annual
 Meeting.
Participates in 15th Biennale of Sydney.
Participates in 3rd Busan Biennale.

2007

Participates in Documenta 12, Kassel, Germany. His
 work *Fairytale* brings 1,001 people, selected from an
 open call on his sina.com blog, from China to Kassel
 during the exhibition's three-month run.

Participates in 2nd Moscow Biennale.

Completes several architectural projects, including Three
 Shadows Photography Arts Center, Beijing; 17 Stu-
 dios, Caochangdi, Beijing; and the Museum of Neo-
 lithic Pottery, Jinhua, Zhejiang Province.

2008

Solo exhibitions include shows at Mary Boone Gallery,
 New York; Sherman Contemporary Art Foundation
 and Campbelltown Arts Centre, Sydney; Groninger
 Museum, the Netherlands; and Gallery Hyundai,
 Seoul.

Participates in 5th Liverpool Biennnial.

Participates in 11th Venice Biennale of Architecture.

Receives Chinese Contemporary Art Awards lifetime
 achievement award.

In statements to the press and articles in the *Guardian*,

renounces Beijing Olympics as a propaganda show
on the part of the Chinese government.

May 12: Massive earthquake strikes Sichuan Prov-
ince. More than five thousand children die owing
to shoddy construction of schools throughout the
province.

2009

Solo exhibitions at Three Shadows Photography Arts
Center, Beijing; and Mori Art Museum, Tokyo.

March: launches a "citizen investigation" into school-
children's deaths in the Sichuan earthquake. Fields a
team of volunteers to gather the names of the chil-
dren who perished.

May: Ai Weiwei's sina.com blog is censored.

June: He begins micro-blogging on Twitter.

August: Ai Weiwei is beaten by police in Chengdu,
where he has come to testify in the trial of environ-
mentalist and earthquake activist Tan Zuoren.

September: Undergoes emergency brain surgery in Mu-
nich for a cerebral hemorrhage believed to be a result
of the police beating.

2010

So Sorry, solo exhibition at Haus der Kunst, Munich. Among the principal works is *Remembering*, an installation on the museum's facade made of nine thousand children's backpacks.

August: In Chengdu to file a police report on the 2009 assault, Ai Weiwei and his colleagues are attacked by plainclothes officers in front of police headquarters.

September: The public art sculpture *Circle of Animals / Zodiac Heads* debuts at the São Paulo Biennial.

October: *Sunflower Seeds*, consisting of a hundred million hand-painted porcelain seeds, goes on view in the Turbine Hall of Tate Modern, London.

2011

April: Ai Weiwei is arrested at Beijing Airport. Eight of his staff members and Ai Weiwei's wife, Lu Qing, are detained.

May: *Circle of Animals / Zodiac Heads* goes on view in New York City at the Pulitzer Fountain near Central Park. A second edition of the sculptures goes on view at Somerset House in London.

June: Eighty-one days after his arrest, Ai Weiwei is released by the Chinese authorities. He is barred from leaving Beijing for a period of one year.

October: Ai Weiwei tops the list of "Power 100" compiled annually by the UK magazine *ArtReview*, which names him "the contemporary art world's most powerful player" of 2011.

2012

Following its debut at the Sundance Film Festival in January, the feature-length documentary *Ai Weiwei: Never Sorry* goes into commercial theatrical release in July.

April: An edition of *Circle of Animals / Zodiac Heads* opens at the Hirshhorn Museum and Sculpture Garden in Washington, DC, where it remains on view through February 2013.

May: *Perspectives: Ai Weiwei*, an exhibition of the monumental 2005 installation *Fragments*, goes on view at the Arthur M. Sackler Gallery in Washington, DC.

August: An edition of *Circle of Animals / Zodiac Heads* is installed at Princeton University, where it remains on view until August 2013.

October: *Ai Weiwei: According to What?* Opens at the Hirshhorn Museum and Sculpture Garden, Washington, DC.

ACKNOWLEDGMENTS

This book could not have come into existence without the help of many people. We are first and foremost grateful to Ai Weiwei's studio associates for their help with this and other projects. Special thanks to E-Shyh Wong, Jennifer Ng. Thanks as well to Jeremy Wingfield and Chin Chin Yap.

Our thanks to Jacob Weisberg and Mort Janklow for the many suggestions that were crucial in turning a vague idea into a concrete concept. Thanks as well to Phil Tinari, Alison Klayman, Lou Sagar, Gary Zarr, Urs Miele, Uli Sigg, David Smallman, Peter Bernstein, Karen Smith, Steven Rodriguez, and Karl Katz of Muse Film and Television for their assistance.

At Princeton University Press, director Peter Dougherty oversaw the project from start to finish alongside the book's editor, Alison MacKeen. Larissa Klein, Terri O'Prey, and Lauren Lepow were also important members of the editorial team. Our thanks as well to the book's designer,

Pamela Schnitter, and to Maria Lindenfeldar, the Press's art director, for the elegant design. Special thanks to Elisabeth Donahue, associate dean for public and external affairs of the Woodrow Wilson School of Public and International Affairs at Princeton. And we would be remiss in overlooking the role of Christina Paxson, then dean of the Woodrow Wilson School, who helped arrange the Ai Weiwei exhibition and initiated the discussions that led to this book.

At AW Asia, Taliesin Thomas provided much of the research that formed the basis of the book. Thanks to Susan Delson for her deft shaping of the manuscript in its later stages.

A profound debt is owed to J. Richard Allen, whose insights and suggestions were crucial throughout the process, and whose ongoing support has been invaluable.

In this as in so much else in my life, my deepest gratitude and love go to my wife, Abbey.

As a friend and collaborator of Ai Weiwei's, I'm honored to have had the opportunity to assemble this book on his behalf. Weiwei had as much input into the book as his current circumstances would allow. I would be remiss

if these acknowledgments did not conclude with my profound gratitude to Ai Weiwei, not only for his encouragement on this project but for his continued commitment to human rights and dignity, and for his steadfast friendship over the years.

<div align="right">LARRY WARSH</div>

ILLUSTRATIONS

All images courtesy Ai Weiwei Studio.

Frontispiece: *Ai Weiwei in the elevator when taken in custody by the police, Sichuan, China, August 2009*, 2009. Photo credit: Ai Weiwei

Page 116: *Brain Inflation*, 2009. Poster, 200 x 100 cm. MRI image showing Ai Weiwei's cerebral hemorrhage as a result of police brutality in Chengdu, China, August 12, 2009. Photo credit: Ai Weiwei

LARRY WARSH has been active in the art world for more than thirty years. He has collaborated with Ai Weiwei on several projects, including the public art installation *Circle of Animals / Zodiac Heads* (2010). The New York presentation of this work at the historic Pulitzer Fountain near Central Park was recognized by the International Art Critics Association as an outstanding public exhibition of 2011.

Warsh is a former member of the Contemporary Arts Council of the Asia Society and the Contemporary Arts Committee of the China Institute. He has also served on the boards of the Museum of Contemporary Art, China; the Alliance for the Arts; and the Getty Museum Photographs Council. He is currently on the board of Muse Film and Television and is a member of the Basquiat Authentication Committee.

"Ai Weiwei is unquestionably one of the most important artists of our time. His practice encompasses the production of objects, the circulation of information, and politics in a manner that is absolutely unique. This worthy compilation of short quotations will introduce a broad audience to his thought and activism, and makes clear the scope and span of this truly global artist."
—DAVID JOSELIT, author of *After Art*

"First, there was Confucius. Then, the sayings of Chairman Mao. And now the pithy, ironic, and humorous insights of Ai Weiwei. I thoroughly enjoyed reading this collection, which reflects a well-developed philosophy as well as a keen understanding of the Chinese Communist system. This is China made easy and interesting."
—JEROME A. COHEN, New York University